Published in 2004 by
Stewart, Tabori & Chang
A Company of La Martinière Groupe
115 West 18th Street, New York, NY 10011

Export Sales to all countries except Canada, France,
and French-speaking Switzerland:
Thames and Hudson Ltd.
181A High Holborn, London WC1V 7QX, England

Canadian Distribution:
Canadian Manda Group
One Atlantic Avenue, Suite 105
Toronto, Ontario M6K 3E7, Canada

Library of Congress Cataloging-in-Publication Data

Montrose, Sharon.
Carry-ons: traveling Chihuahuas / Sharon Montrose ; text by Spencer Starr.
p. cm.
ISBN 1-58479-322-8
1. Chihuahua (Dog breed) 1. Starr, Spencer. II. Title.

SF429.C45M674 2004
636.76—dc22
2003067229

Designed by Sally Ann Field
Text by Spencer Starr
The text of this book was composed in Cocktail Shaker by Chank Diesel, Agenda Light and Medium

Printed in China

10 9 8 7 6 5 4 3 2 1

First Printing

carry-on car·ry-on (ˈkar-ē-ōn) *n.* a bag, suitcase or other small item. *adj.* small or compact enough to be taken aboard and stowed on an airplane, train, or bus by a passenger. carry on *v.* to hold or support while moving, bear; to take from one place to another, transport.

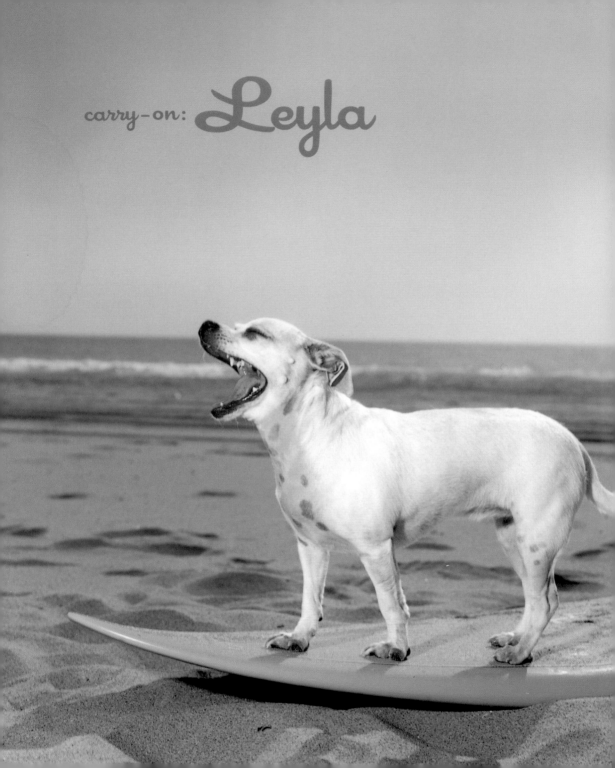

carry-on: *Leyla*

PLACES LEYLA TRAVELS • MAIN STREET • VENICE BEACH FARMER'S MARKET
• ROSE CAFE • ZJ SURF SHOP • THE NORTH SHORE

favorite place : lifeguard station 17 at will rogers state beach

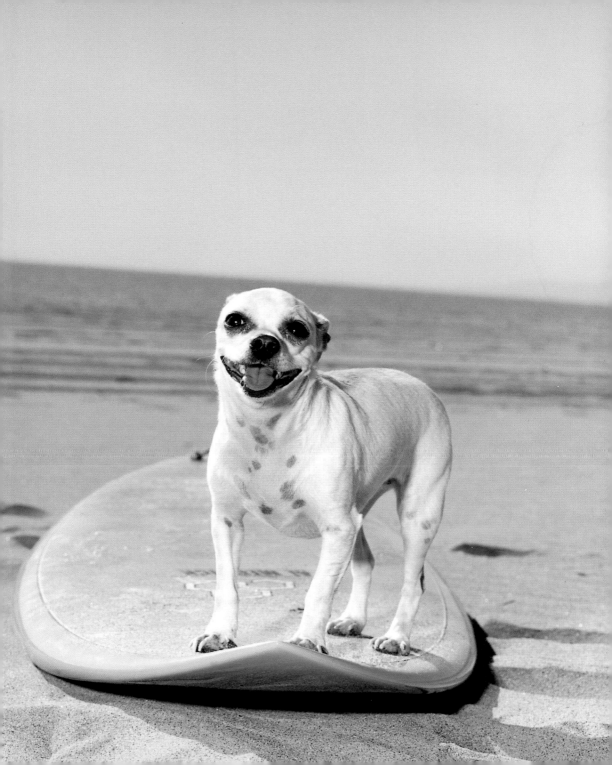

carry-on: Vida

favorite place : the laundromat

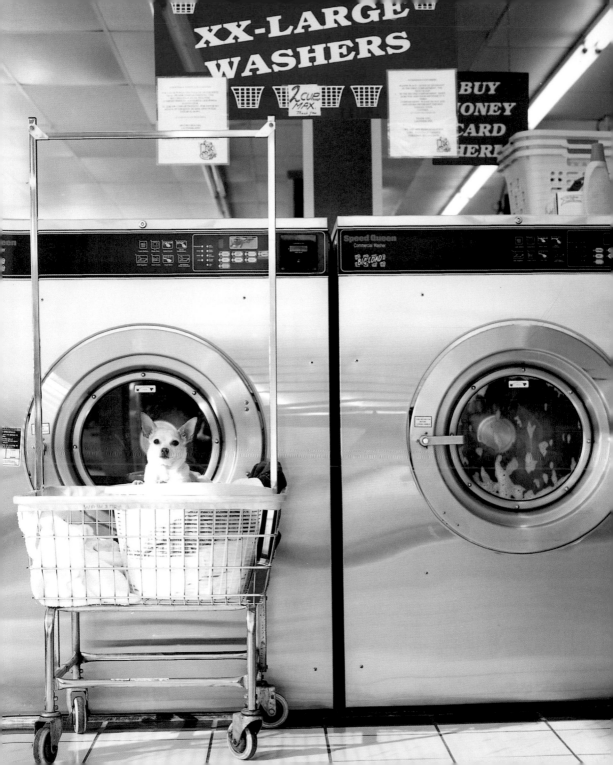

favorite place : the hollywood walk of fame

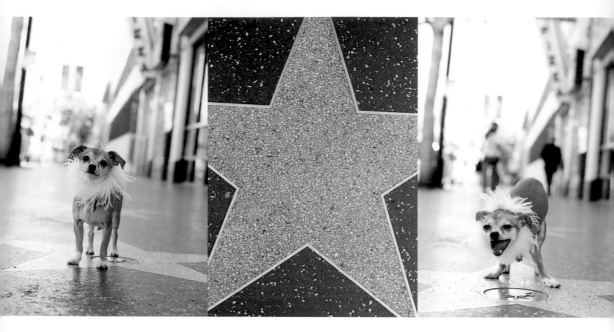

carry-on: Chi Chi

PLACES CHI CHI TRAVELS • PINK'S HOT DOGS • GRAUMAN'S CHINESE THEATER
• PARAMOUNT STUDIOS • BIRD'S CAFE • SAMUEL FRENCH BOOKSTORE

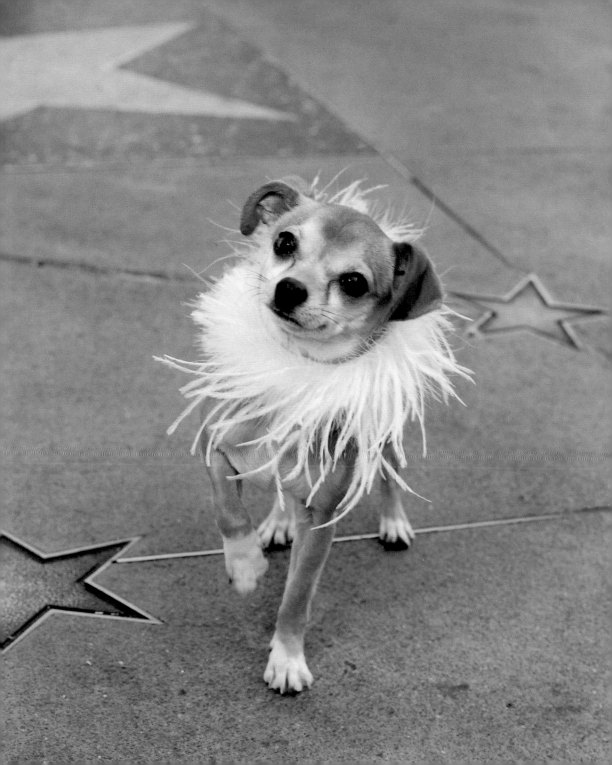

carry-on: Sea Bass

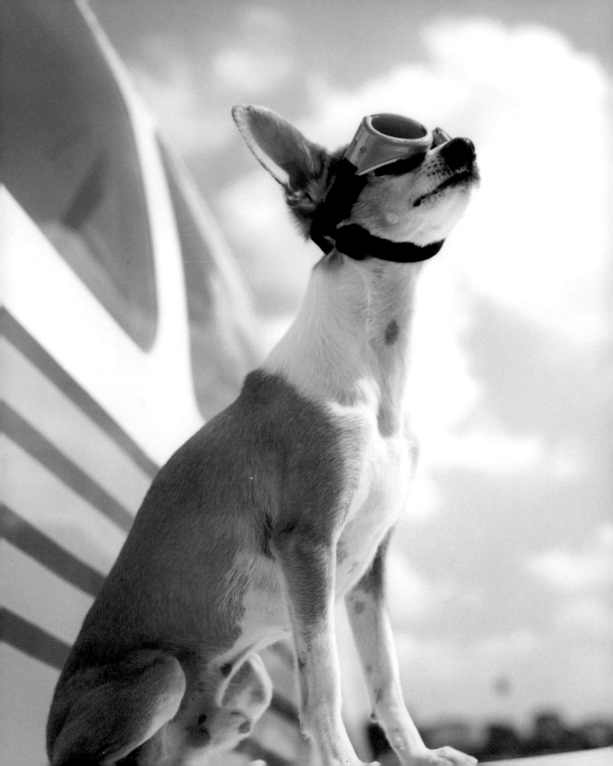

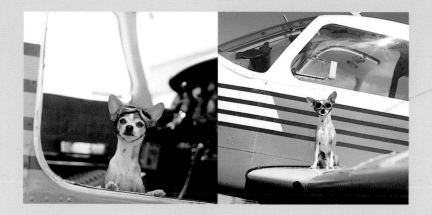

favorite place : copilot chair in his owner's

1979 piper archer 99 at cruising altitude

*favorite place : **plummer park***

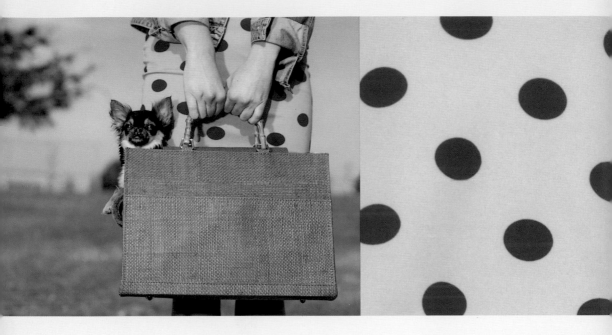

carry-on: Chewy

PLACES CHEWY TRAVELS • LA EYEWORKS • NEW BEVERLY CINEMA • J CREW
• CAFE TARTINNE • OFFICE DEPOT

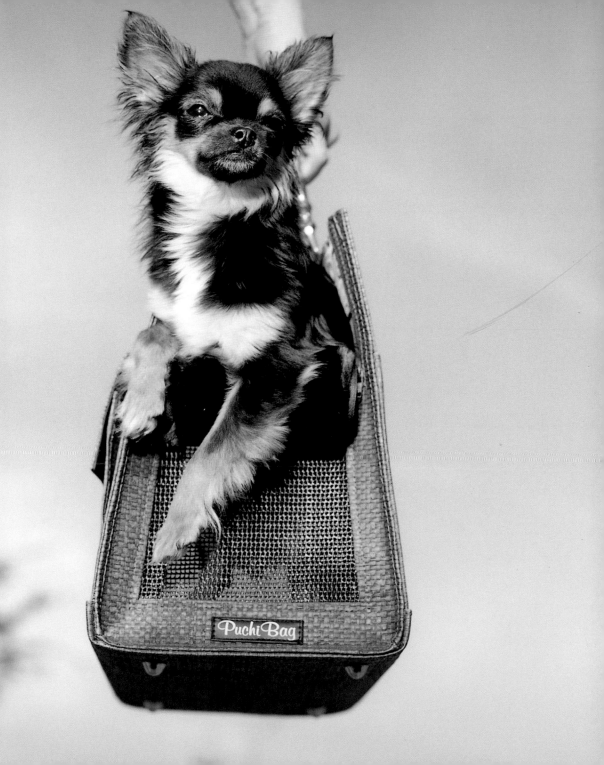

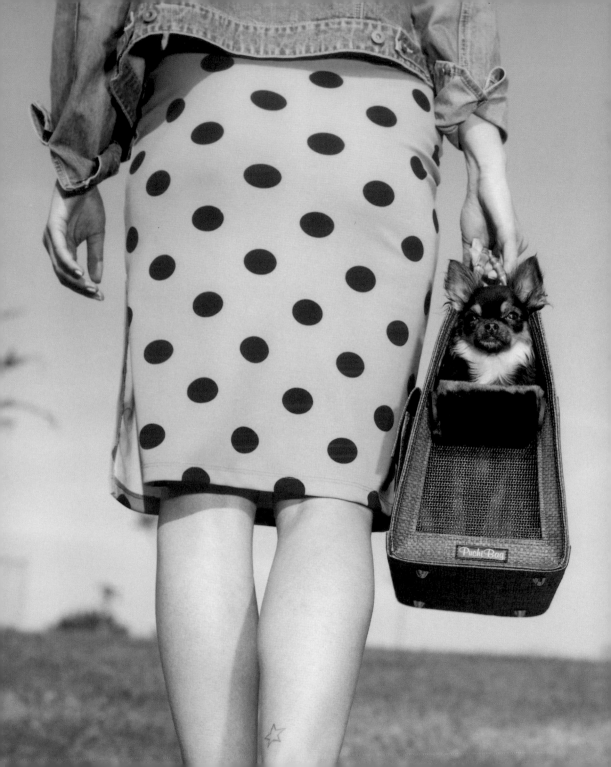

carry-on: Marshall

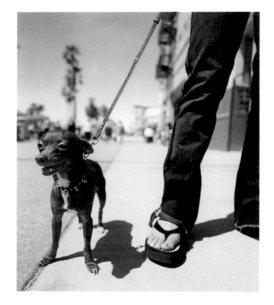

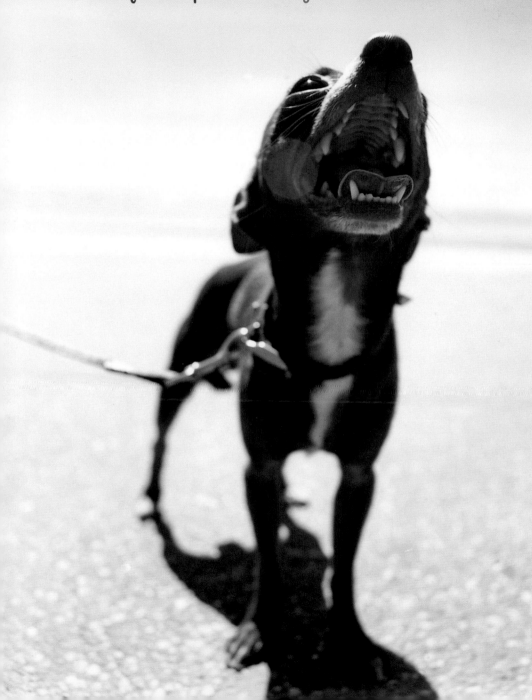

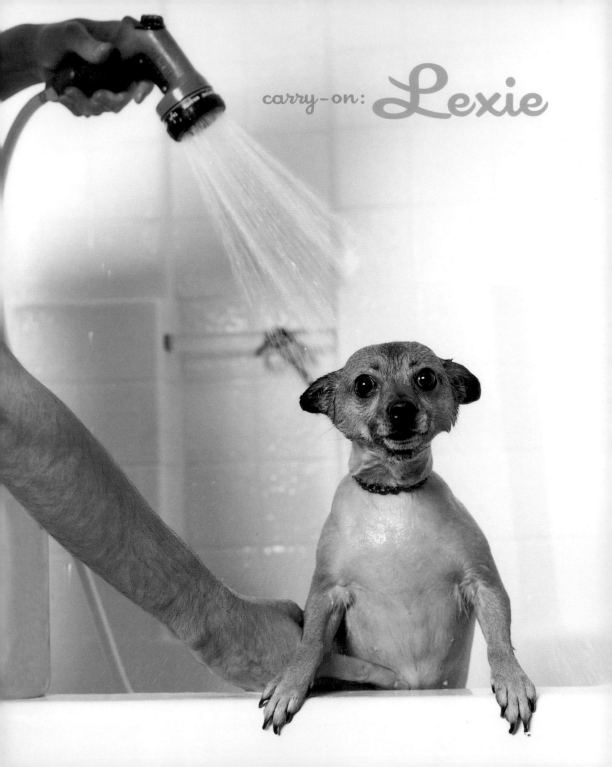

carry-on: *Lexie*

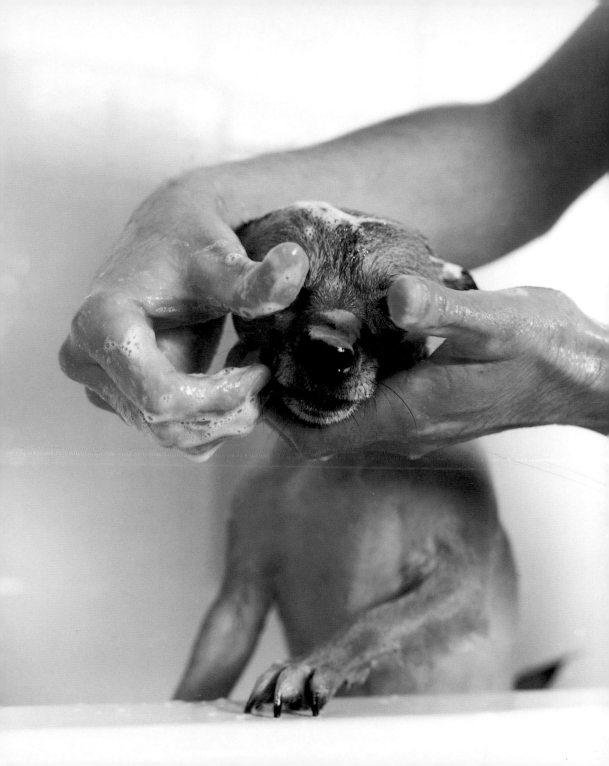

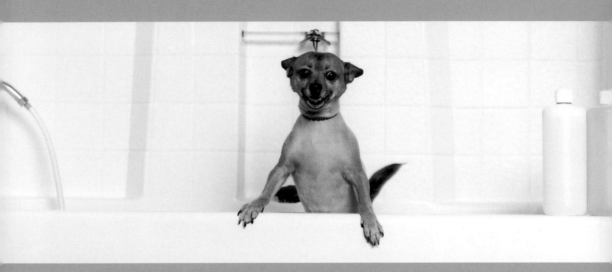

favorite place : getting bathed
by her favorite groomer at catts & doggs

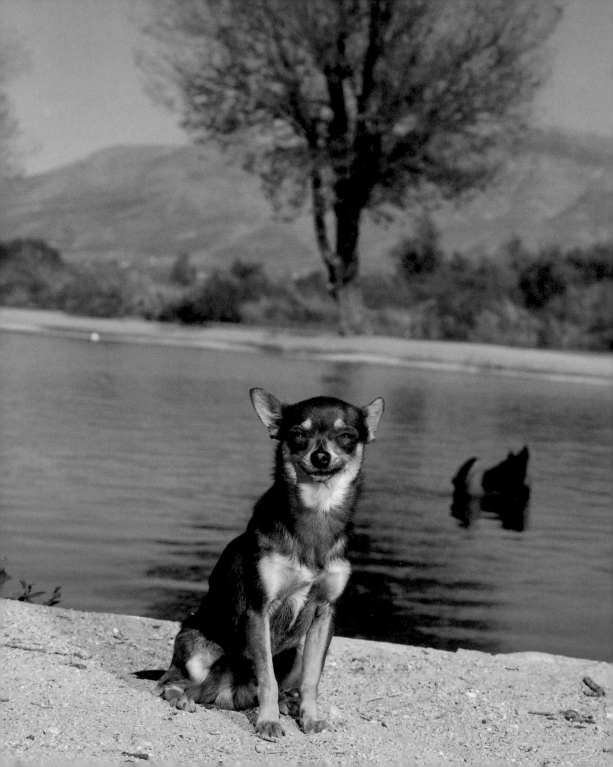

carry-on: Cody

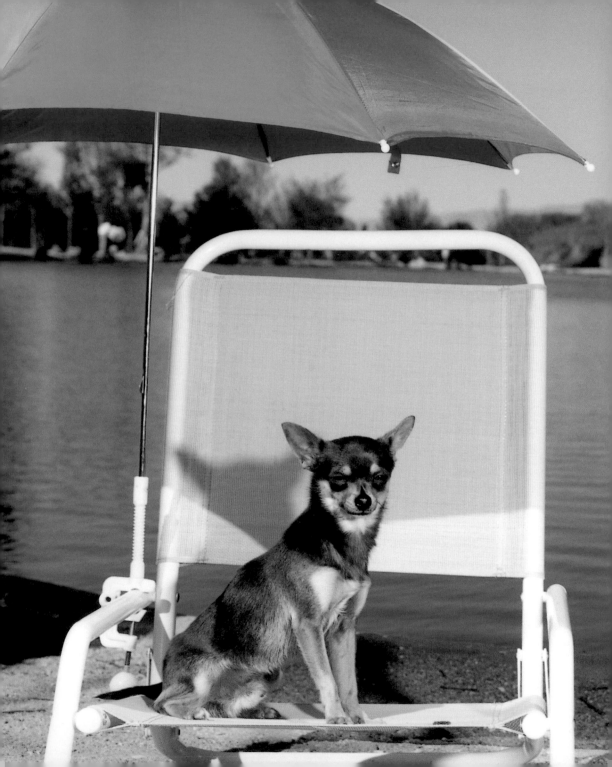

favorite place : sittin' in the sun on the shore of lake hesperia

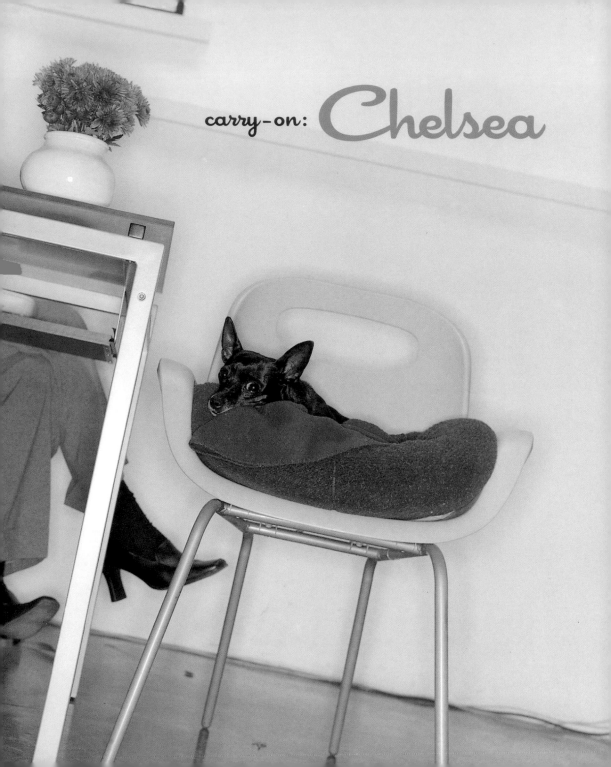

carry-on: *Chelsea*

favorite place : **her owner's office**

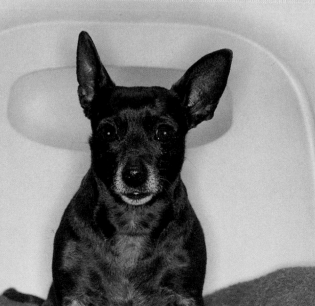

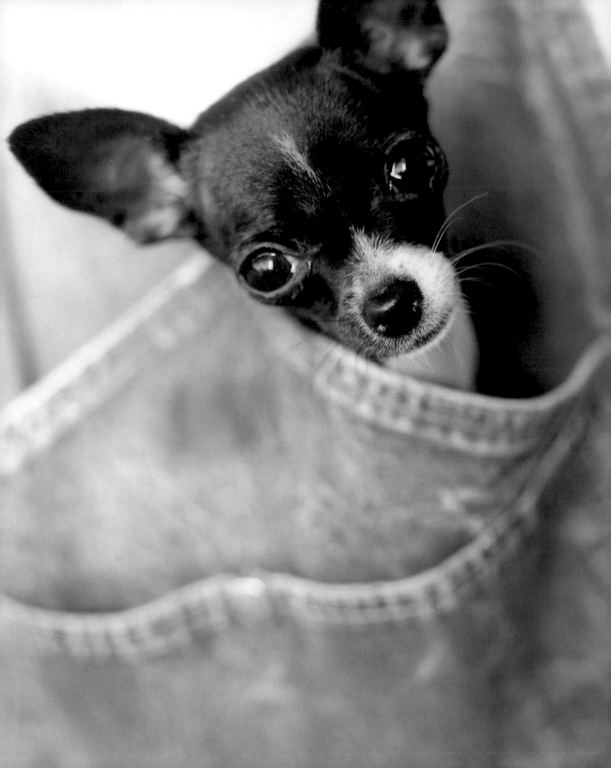

PLACES CARTER TRAVELS

· ISLA VISTA MARKET · PRIMETIME VIDEO

· THE QUAD AT PHYSICAL SCIENCES · WOODSTOCK'S PIZZA

· THE BLUFFS NEAR CAMPUS POINT

carry-on: *Carter*

favorite place : saturdays at the santa barbara
drum circle, snuggling in her owner's overalls

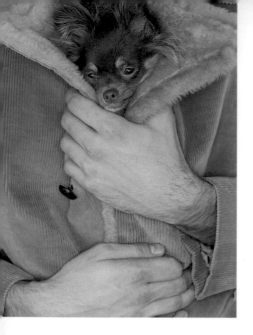

carry-on: **Lola**

favorite place : her owner's coat pocket

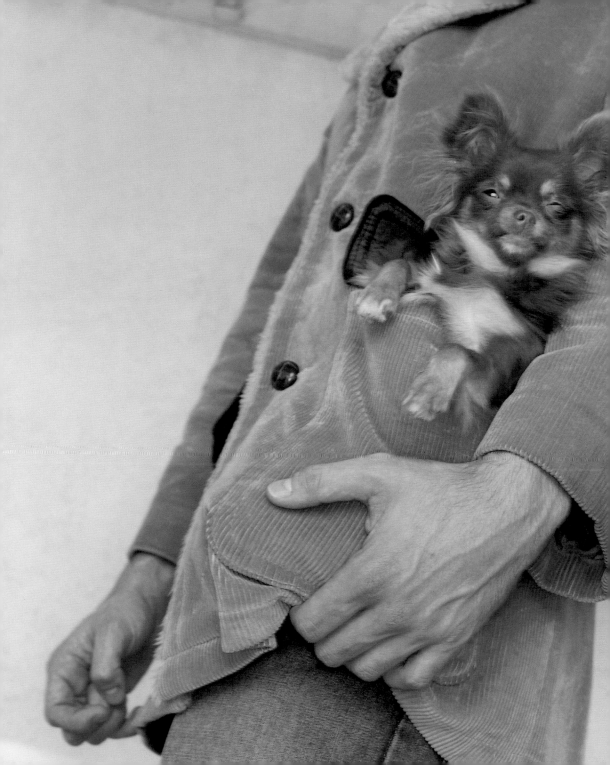

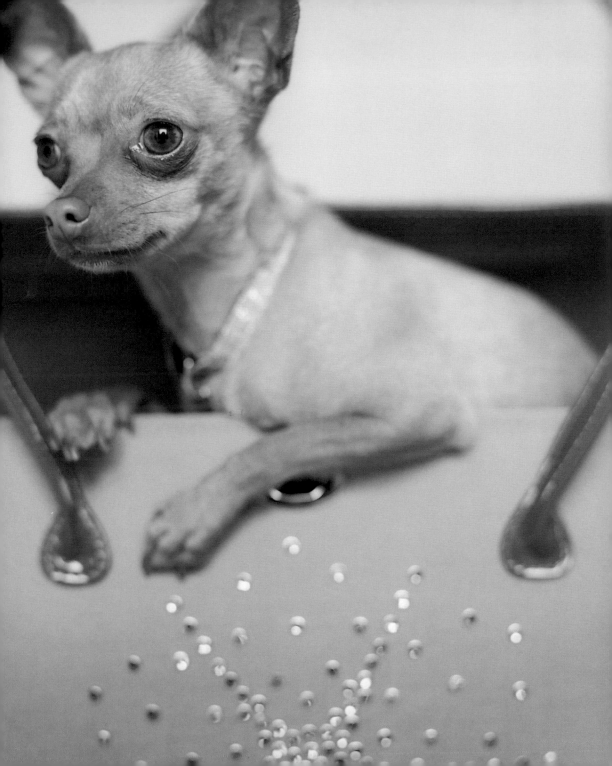

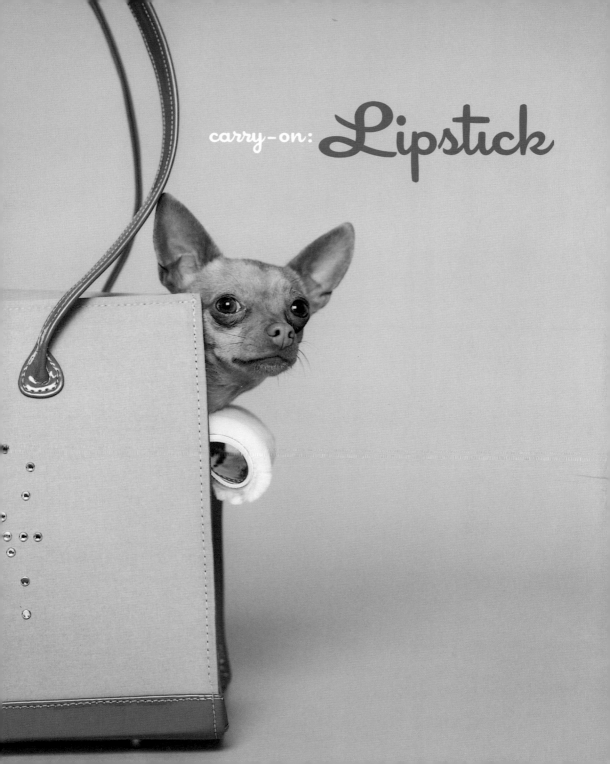

carry-on: *Lipstick*

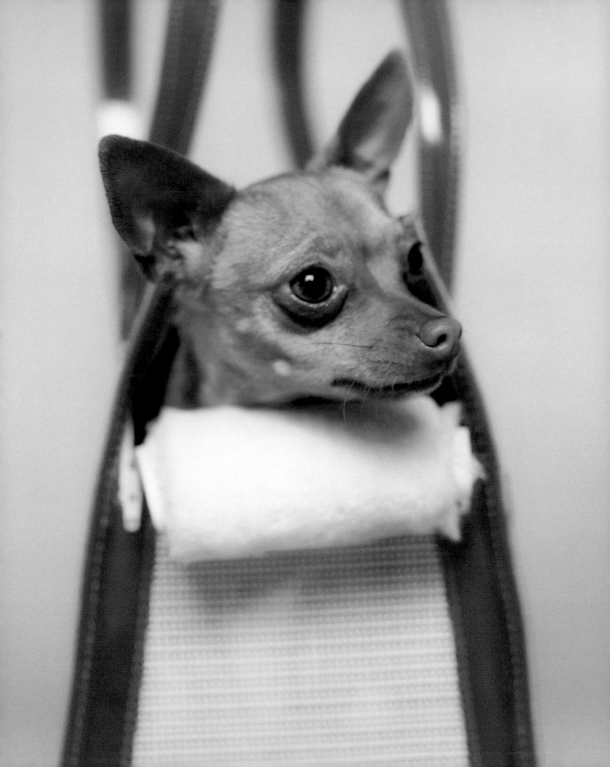

favorite place : **in her pink puchi bag with rhinestones**

PLACES LIPSTICK TRAVELS • VICTORIA'S SECRET • NAIL HUT ON BEVERLY BOULEVARD
• SERENITY GARDEN AT ELIXIR TEA ROOM • FORNARINA • W HOTEL

carry-on: Bonnie

favorite place : in her
owner's stetson watching the
hesperia rodeo parade

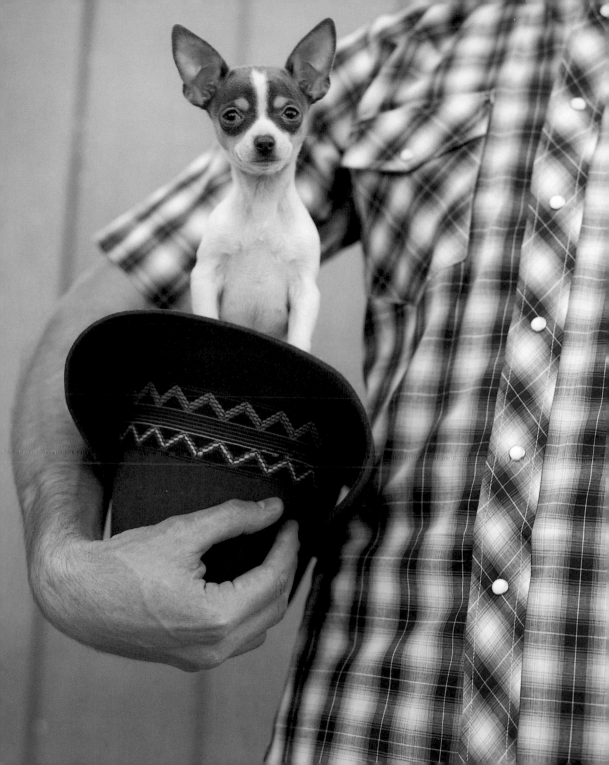

carry-on: *Yoda*

PLACES YODA TRAVELS • CHAMPS ELYSEES • VINEYARDS OF CHATEAU LA TOUR IN BORDEAUX
• SUMMER HOME AT MONTMARTRE • SHOPPING ON AVENUE MONTAIGNE
• STAGE 14 2002 TOUR DE FRANCE, atop MOUNT VENTOUX

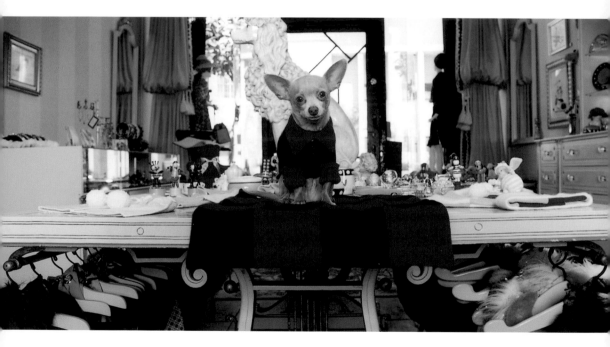

favorite place :

modeling his latest look on the grand table at fifi & romeo

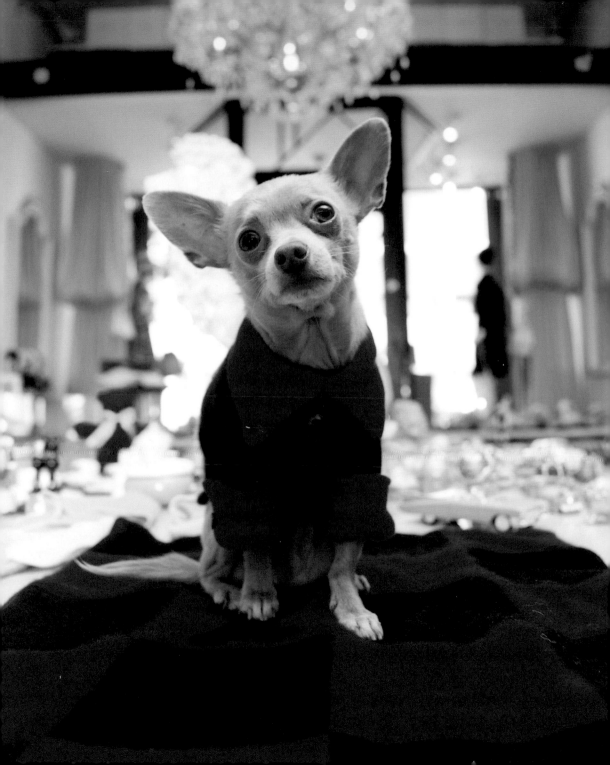

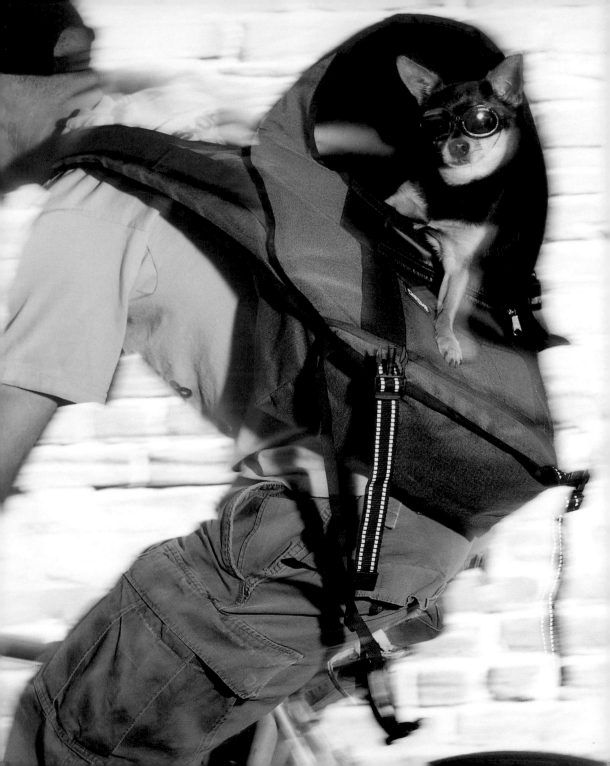

carry-on: *Chili*

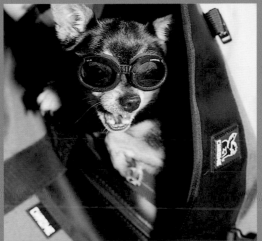

favorite place : flying down bush street in his chrome bag

carry-on: *Lucy*

favorite place : roy's cafe and motor lodge rest stop,
just off route 66, amboy, california

PLACES LUCY TRAVELS • ANNUAL ROUTE 66 RENDEZVOUS IN BARSTOW • FOUR CORNERS • ANGELS BARBERSHOP, SELIGMAN, ARIZONA • INTER-TRIBAL AND NAVAJO TRADING POST, GALLUP, NEW MEXICO • THE WORLD'S LARGEST TOTEM POLE, CLAREMORE, OKLAHOMA

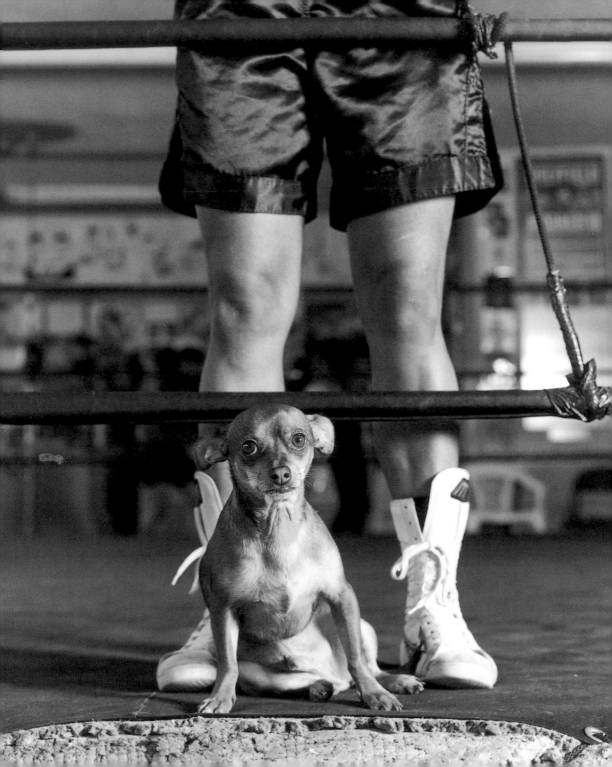

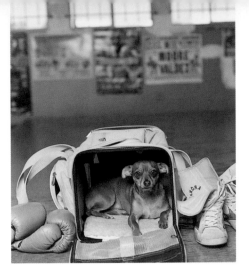

carry-on: Quincy

favorite place : ringside

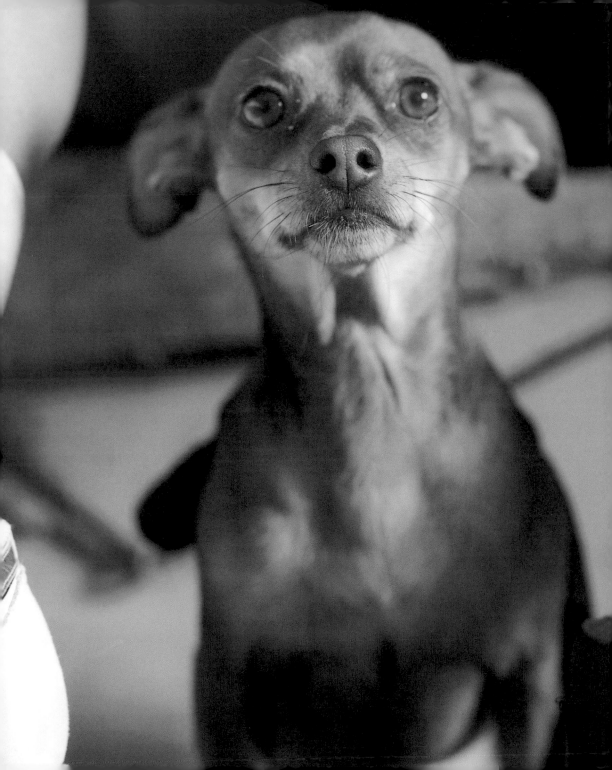

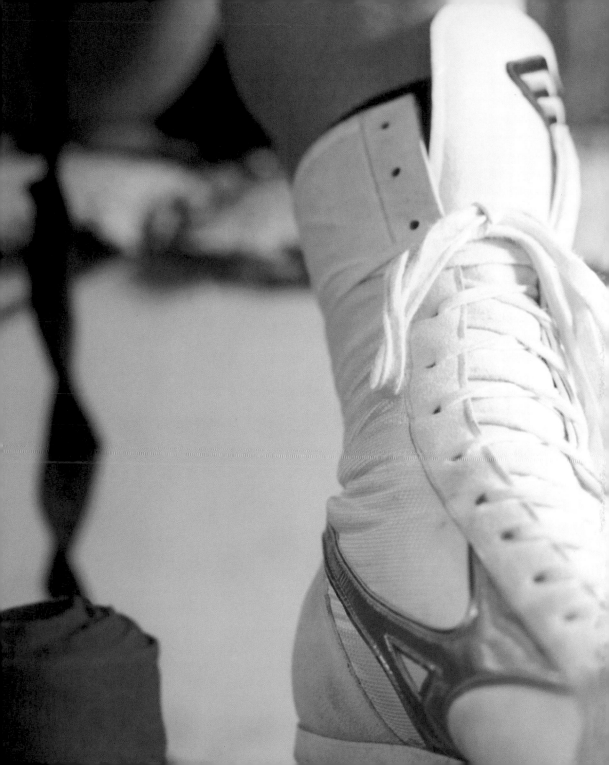

PLACES PEE WEE TRAVELS • McDONALD'S DRIVE THRU
• THE MONTHLY SAN BERNARDINO BBQ MEETUP • BILLY T'S FAMILY
RESTAURANT IN VICTORVILLE • UNDER THE DINNER TABLE

carry-on: Pee Wee

favorite place:
sneaking the last sip at the annual picnic

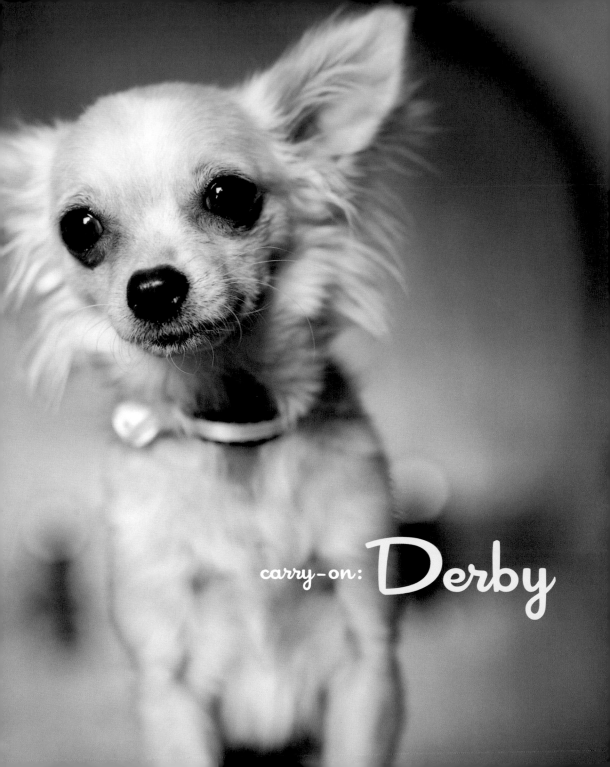

carry-on: Derby

PLACES DERBY TRAVELS • CHATEAU MARMUTT • DAY SPA AT CLASSICUT • FRED SEGAL'S LEASH AND COLLAR DEPARTMENT • THE PATIO AT THE IVY • BRISTOL FARMS MARKET

favorite place : center stage

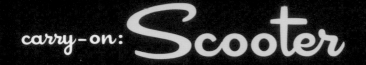

carry-on: Scooter

PLACES SCOOTER TRAVELS • CINCO DE MAYO FIESTA IN ROSARITO • HERMOSA BEACH PIER
• CABO CANTINA • ANNUAL FOURTH OF JULY BBQ • SATURDAY BREAKFAST AT ROCKY COLA CAFE

favorite place : happy hour at the sunset trocadero

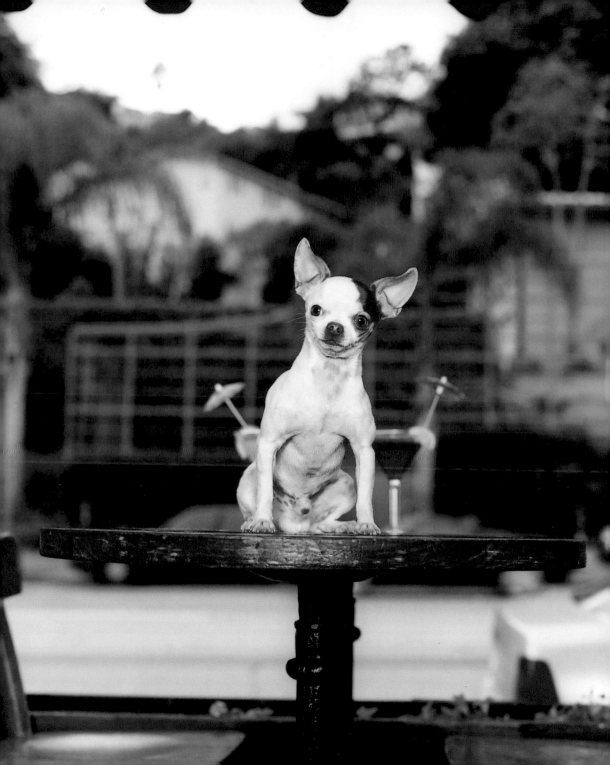

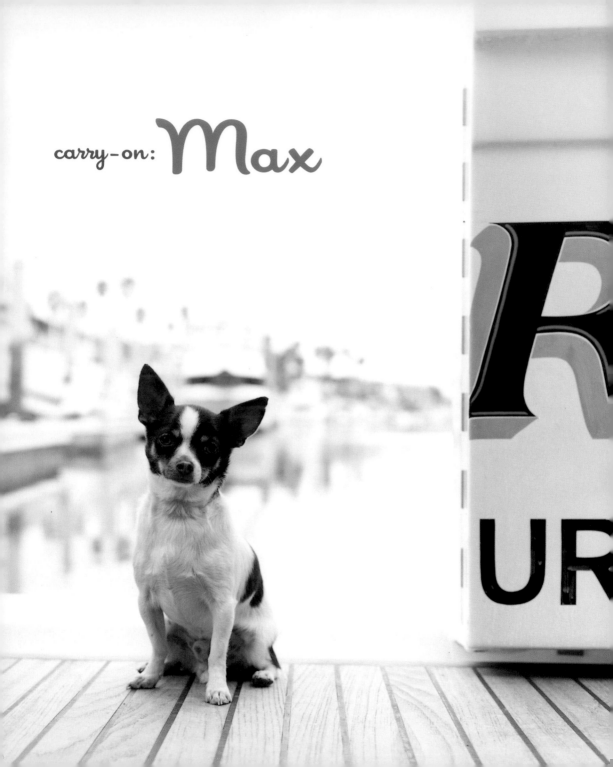

carry-on: Max

favorite place : *deckside on lazy sunday afternoons*

PLACES MAX TRAVELS
• BOATER'S WORLD • SAN MIGUEL ISLAND CAMPGROUNDS
• VENTURA HARBOR ANNUAL POWER BOAT RACE • CATALINA HARBOR
• THE "SECRET FISHING SPOT" OFF BAJA

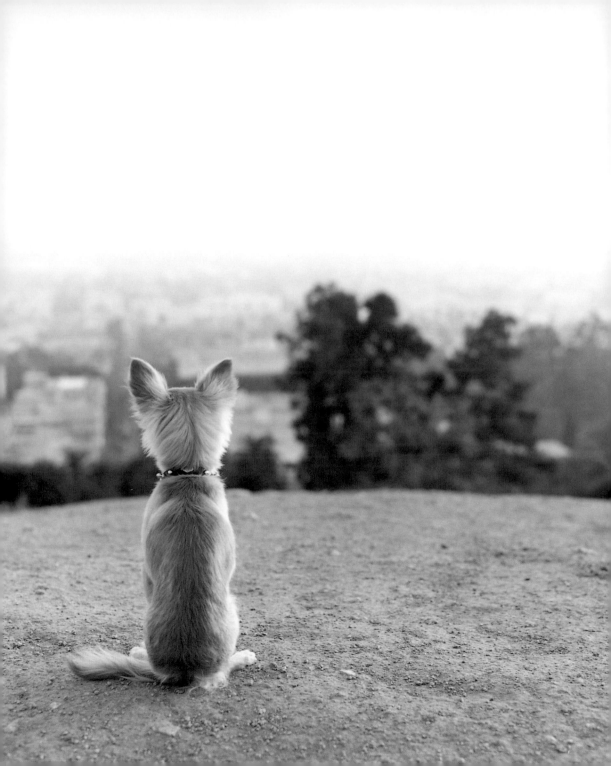

carry-on: **Becca**

favorite place : anywhere with a view

PLACES MOMO TRAVELS • SAMY'S CAMERA
• DOUGHBOY'S CAFE • ICON PHOTO LAB
• PEARL ART SUPPLY • HOME DEPOT • IN-N-OUT BURGER

carry-on: Momo

favorite place :
the front seat with the wind in his fur

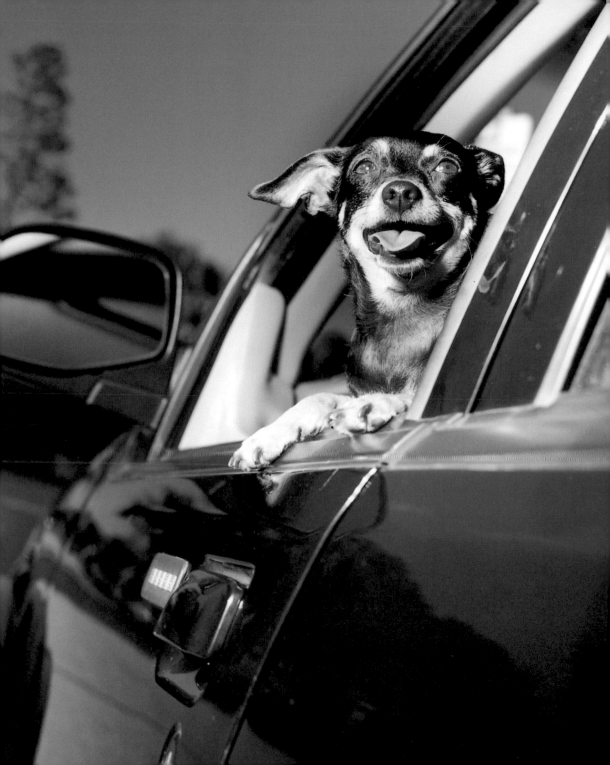

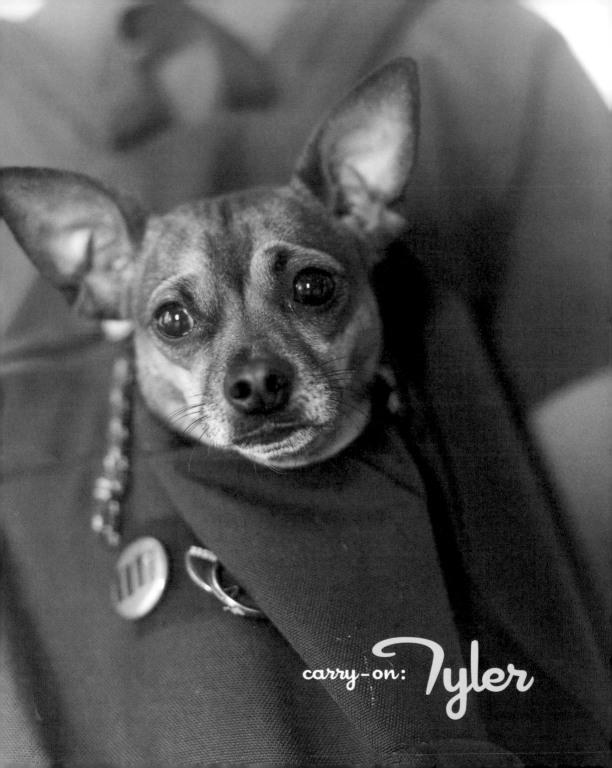

carry-on: *Tyler*

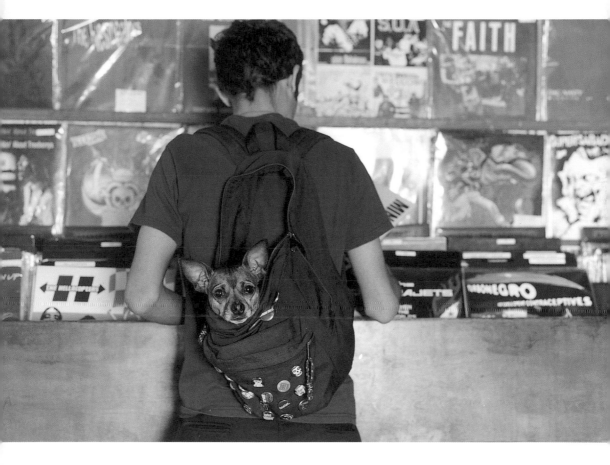

PLACES TYLER TRAVELS · THE PCH CLUB · ASTRO BURGER · THE SMELL

· LOS ANGELES PUNK ROCK RECORD SWAP · MADAME MATISSE CAFE

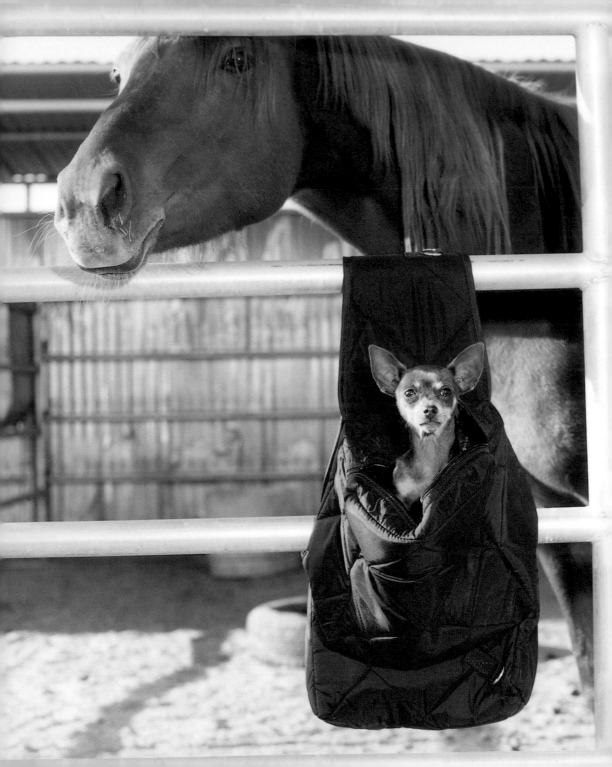

favorite place :

in her friend cappuccino's saddle bag

carry-on : **Mia**

PLACES MIA TRAVELS • AUBURN TACK & FEED
• THE TRAILS AT WILL ROGERS STATE PARK • GOLDSPIRIT FARM
TRAINING GROUNDS • THE EQUINE SPORT MASSAGE
THERAPY CENTER IN WINCHESTER

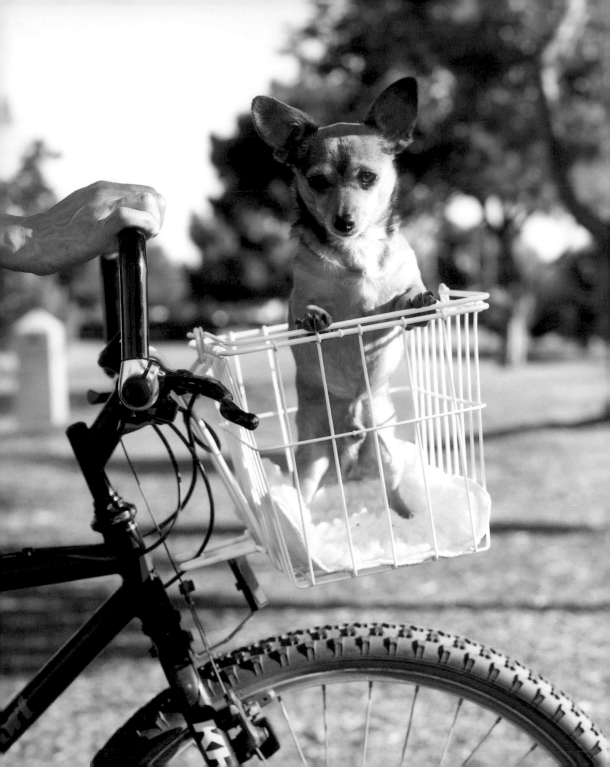

carry-on: Kirby

PLACES KIRBY TRAVELS • LAKERS' TAILGATE PARTIES AT STAPLES CENTER
• THE SANTA MONICA STEPS • EL PORTO JUICE COMPANY • BEACH HOUSE HOTEL & RESORT
• THE HISTORIC POINT VICENTE LIGHTHOUSE IN PALOS VERDES

favorite place : riding up front on the manhattan beach bike trails

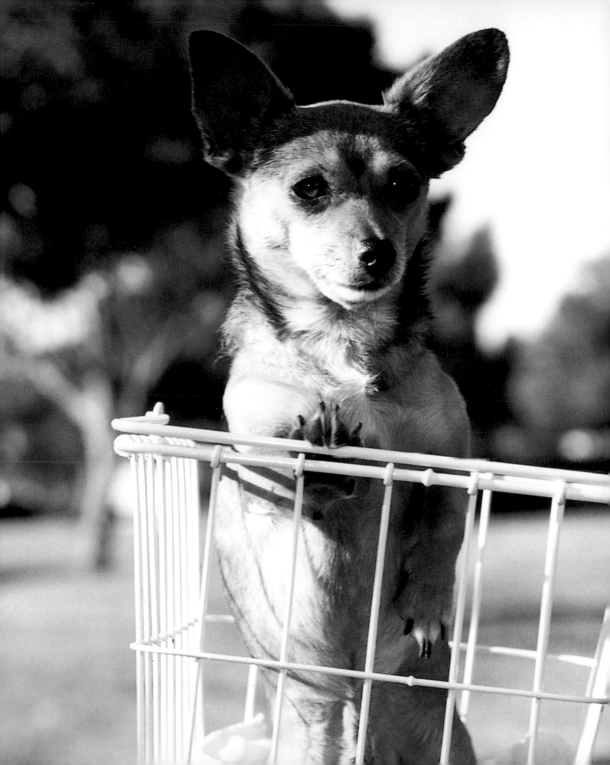

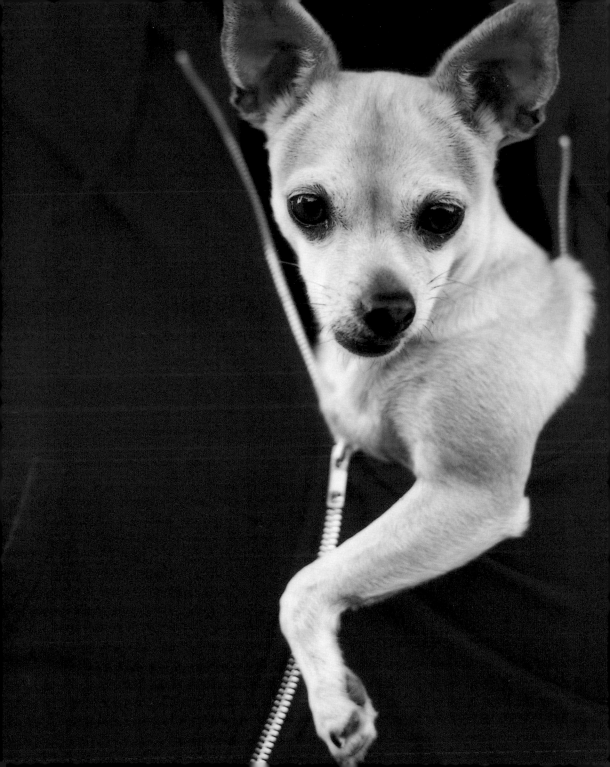

favorite place : snuggled up checking out
the latest magazines at the los feliz newstand

carry-on : Maude

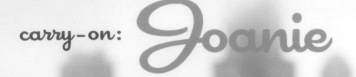

carry-on: *Joanie*

favorite place : chicago rooftops

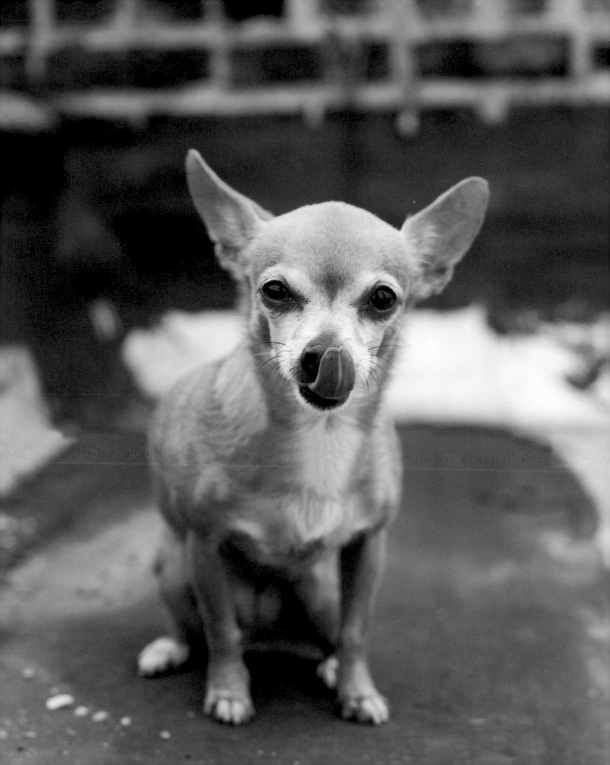

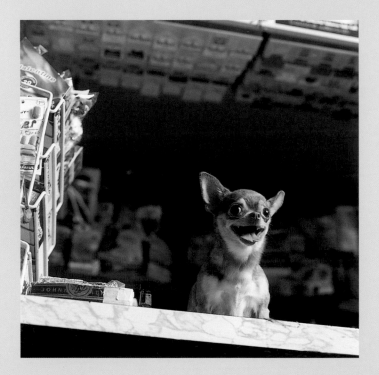

carry-on: Noodle

favorite place : hanging out at pacific market and liquor

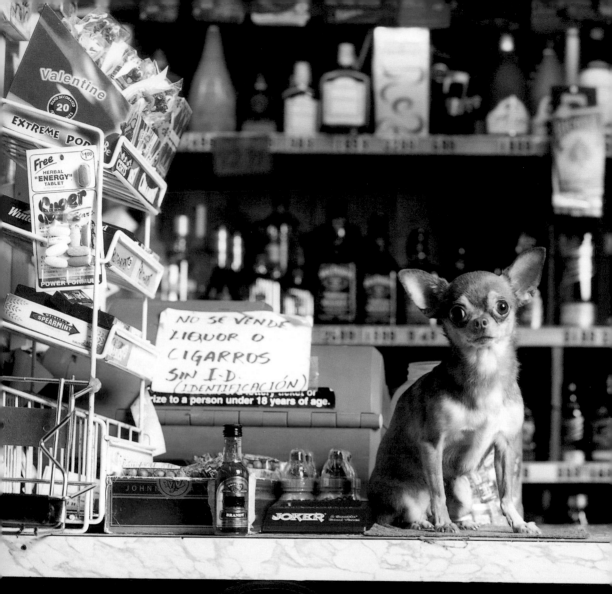